Vintage Christmas Postcards 3
(25 Grayscale Images)

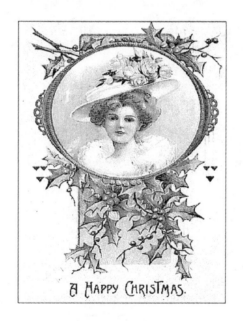

A HAPPY CHRISTMAS.

Adult Coloring Book
GRACE BRANNIGAN

Design Elaine Warfield

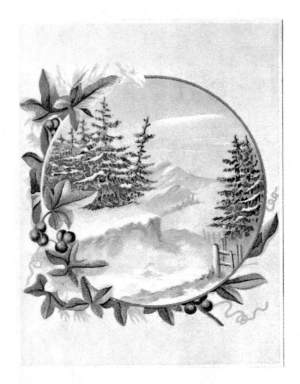

Author Website: http://www.ColoringBooksForAdults.info
Vintage Christmas Postcards 3: 25 Grayscale Images, Adult Coloring Book
Copyright 2015 Elaine Warfield
ISBN-13-978-1519680594
ISBN-10: 1519680597
Please check out my other coloring books:
Detailed Mandala Coloring Books 1 through 4
Detailed Alphabet Coloring Book: 25 Baroque Grayscale Images
Renaissance Masks: 25 Grayscale Images
On the Go Pocket Size Coloring Books

Questor Books, P.O. Box 100, East Jewett, New York, 12424 USA

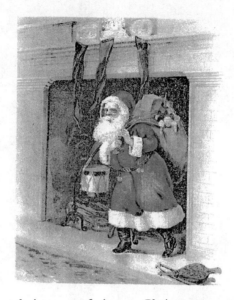

This coloring book has 25 Grayscale images of vintage Christmas postcards from the late 1800's to the early 1900's. Stunning postcard images for your coloring pleasure!

∞ ∞ ∞ ∞ ∞ ∞ ∞ ∞ ∞ ∞ ∞ ∞ ∞ ∞ ∞ ∞ ∞ ∞

How to Color Grayscale: Coloring *Grayscale* images is a fun way to explore and color and it makes shading easier to learn when you follow the shading already in the images. The end result is a uniquely rich and rewarding colored image. The cover for this book was colored using permanent markers, gel pens and watercolor pencils. Experiment, have fun!

Coloring has been shown to reduce stress and offer meditative release. Create your own visually appealing art using crayons, colored pencils, felt tip markers, ink pens, art pencils, gel pens, glitter pens. There is no limit to your creativity and genius.

Please leave a review where you bought this coloring book and share your coloring images. It really helps the author and other buyers. Please check out my other coloring books and visit my Facebook page **Coloring Books for Adults Info.**

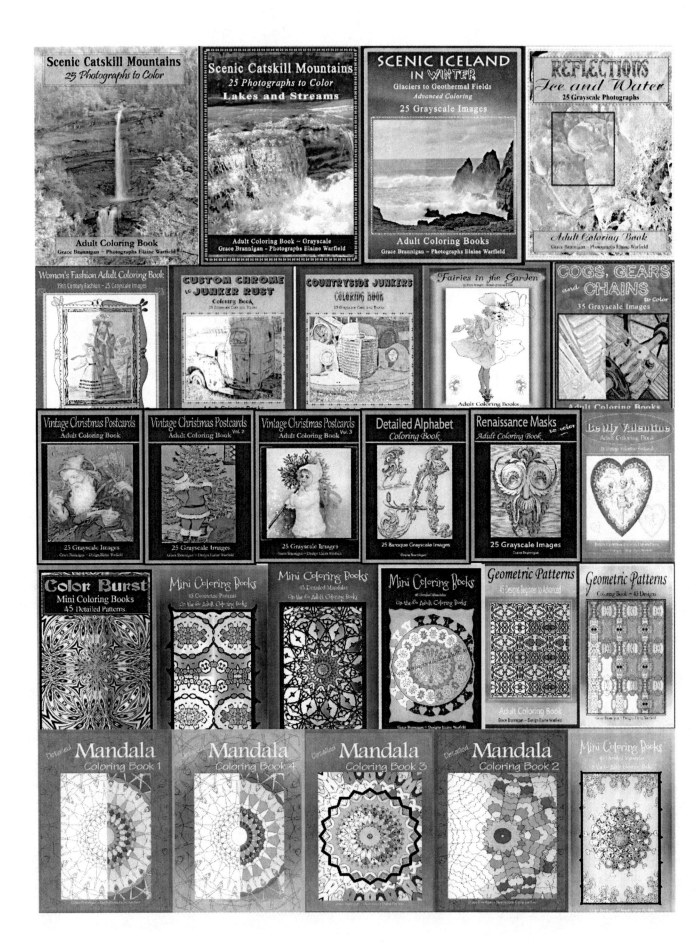

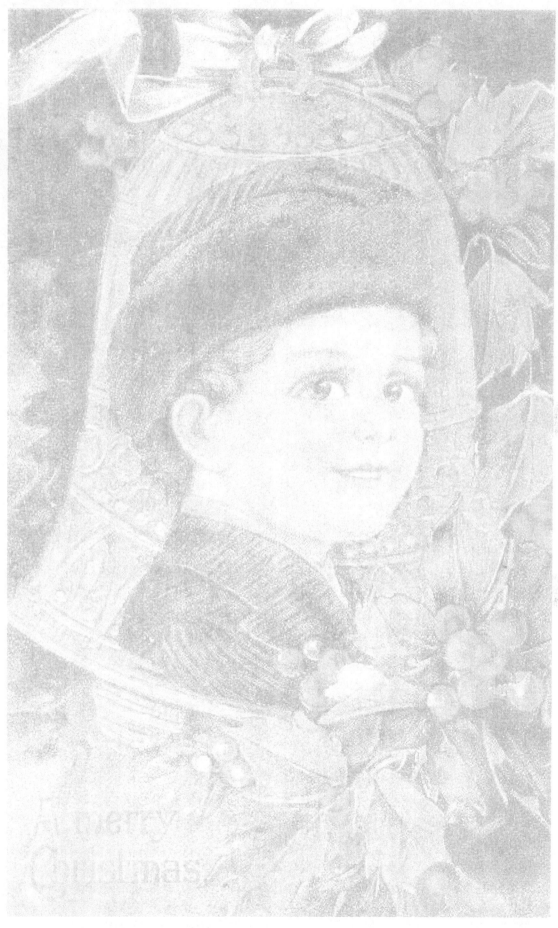

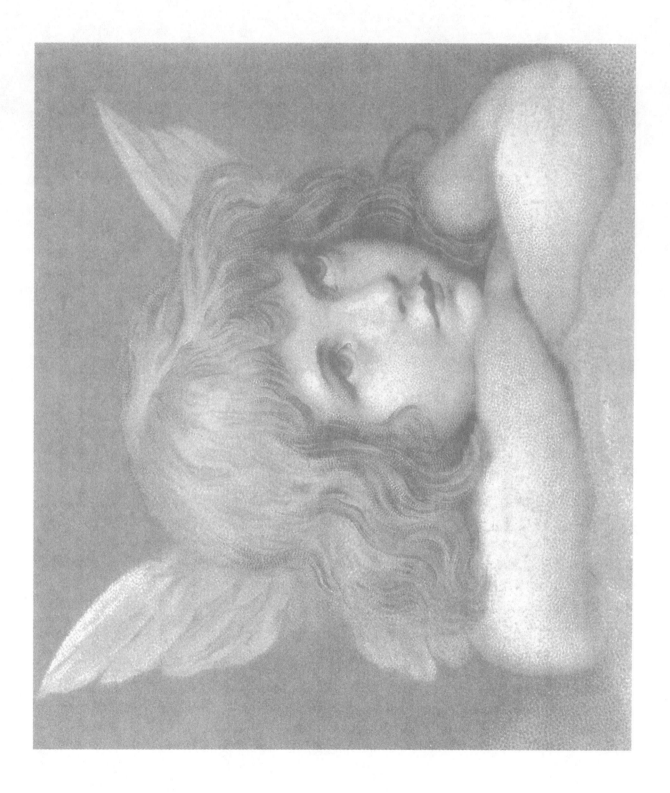

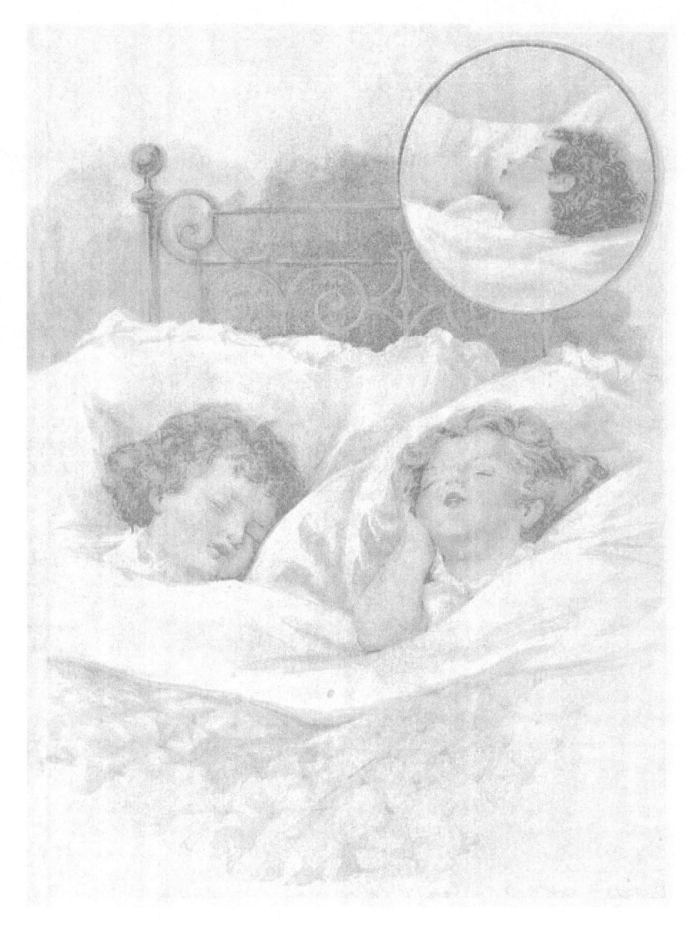

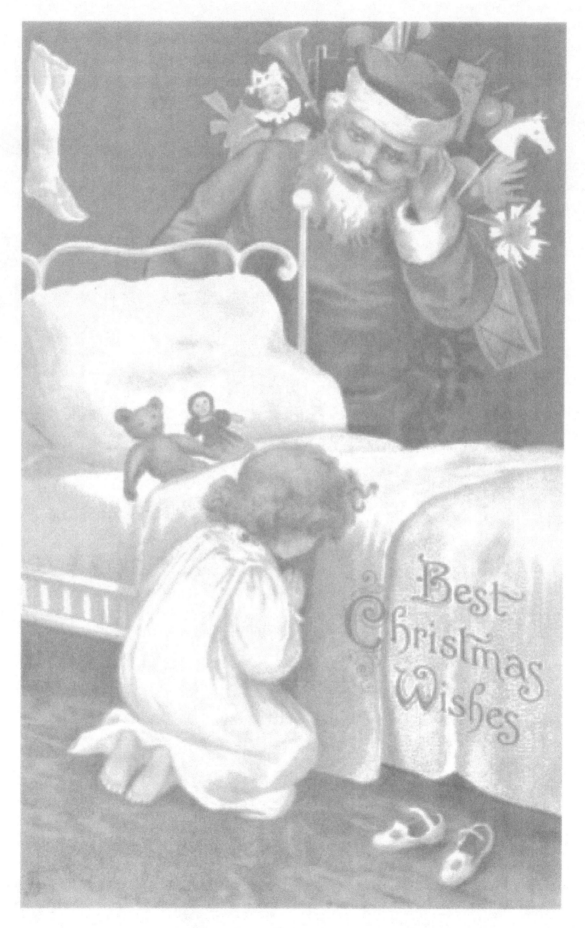

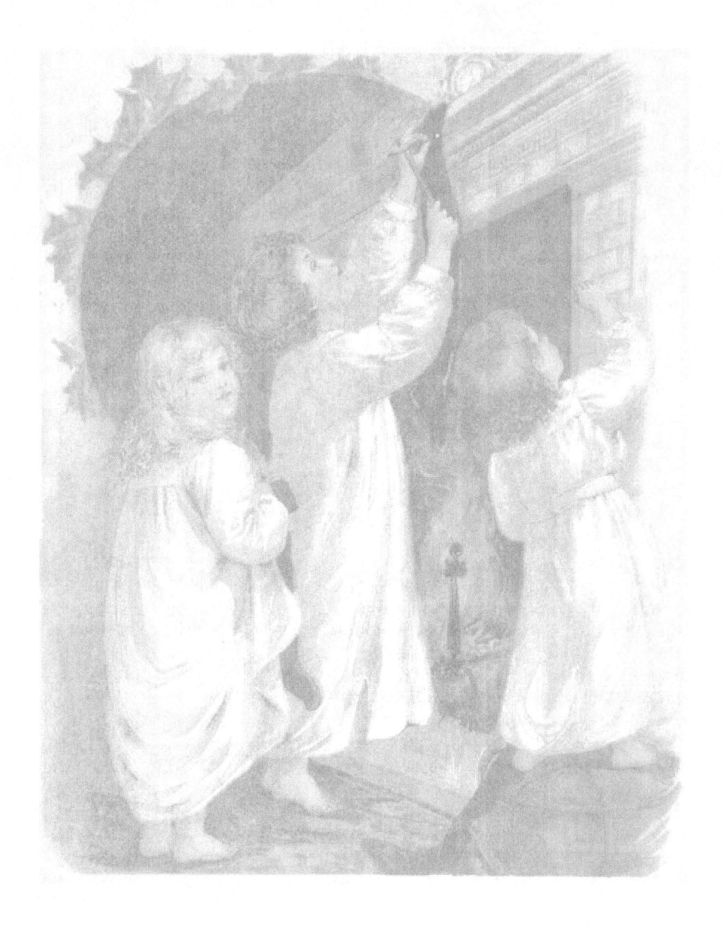

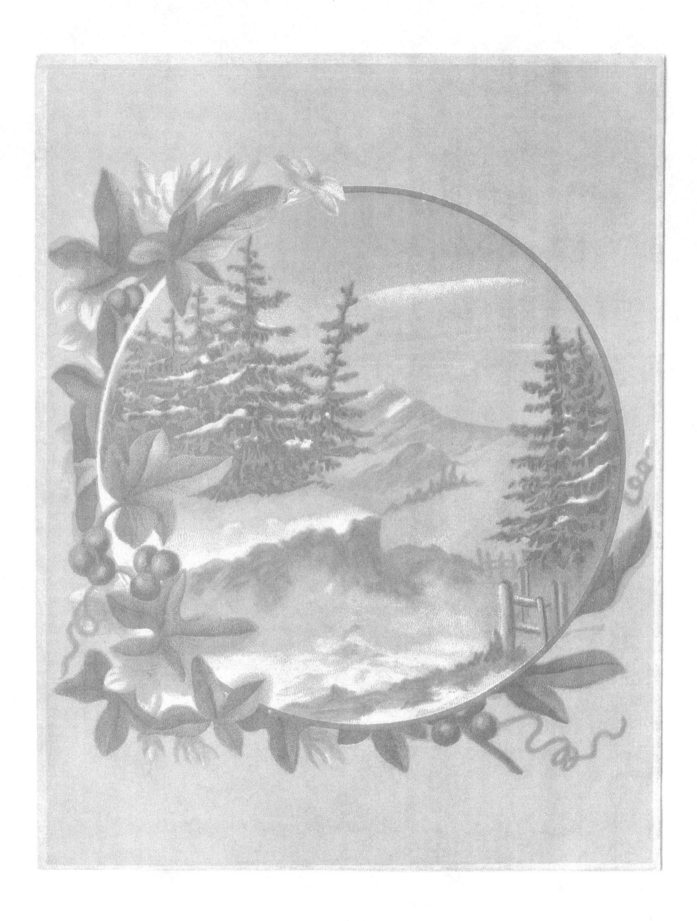

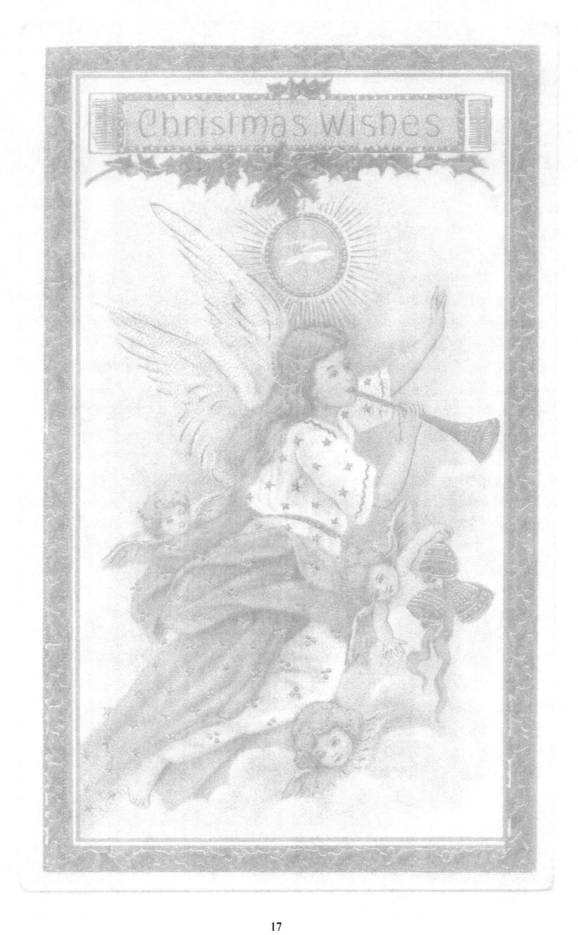

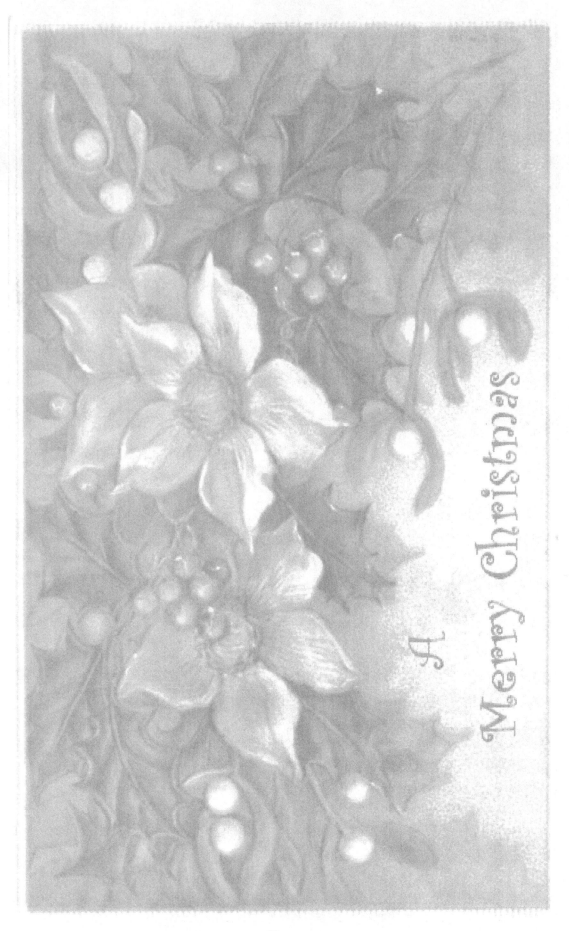

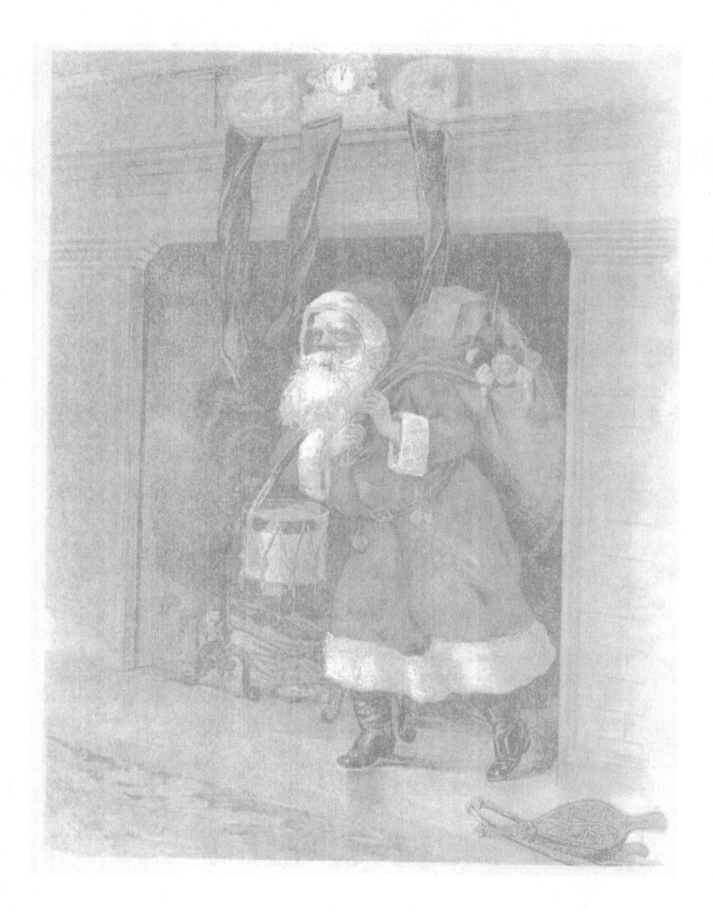

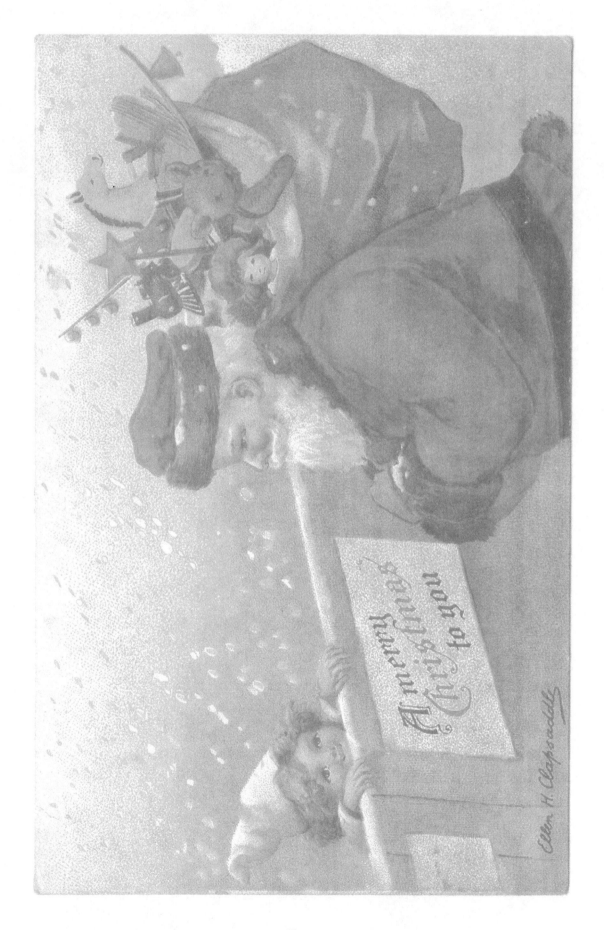

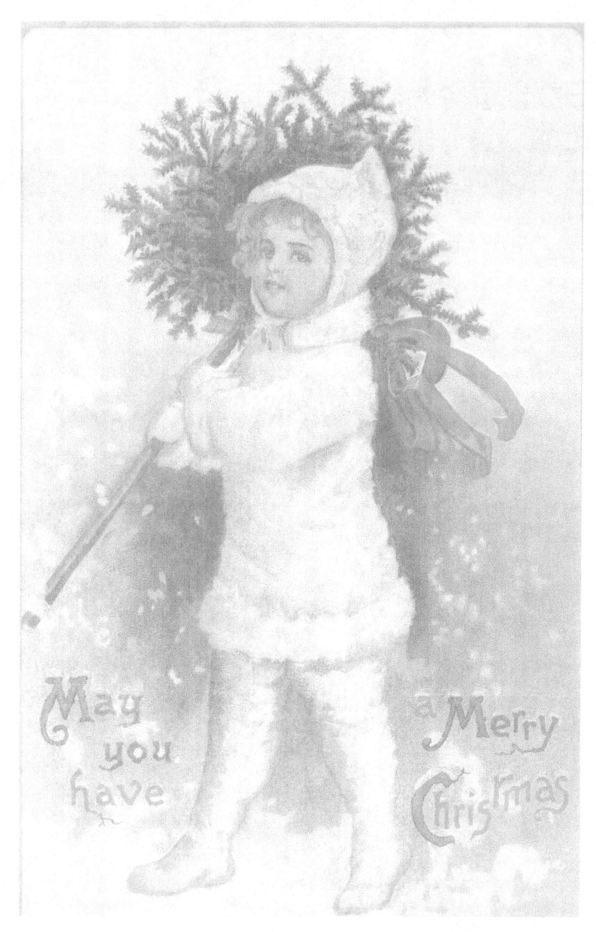

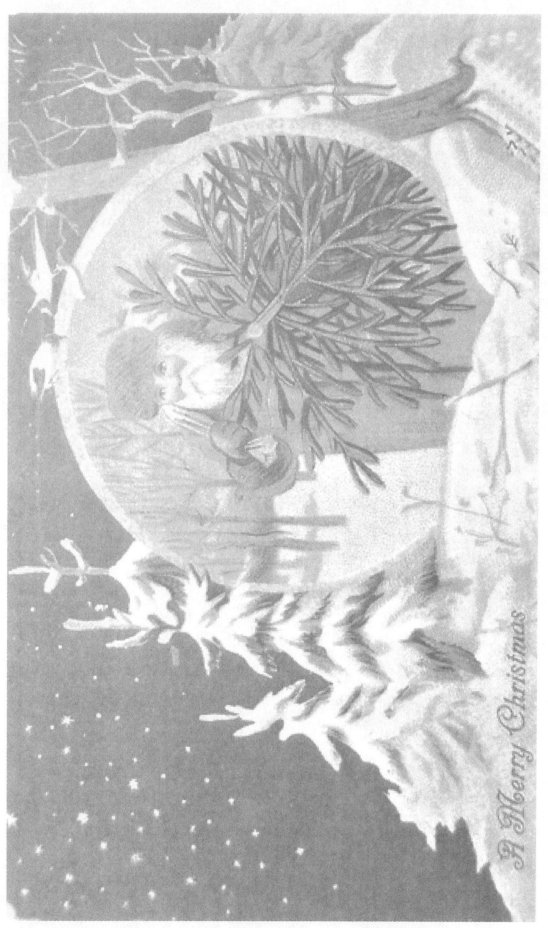

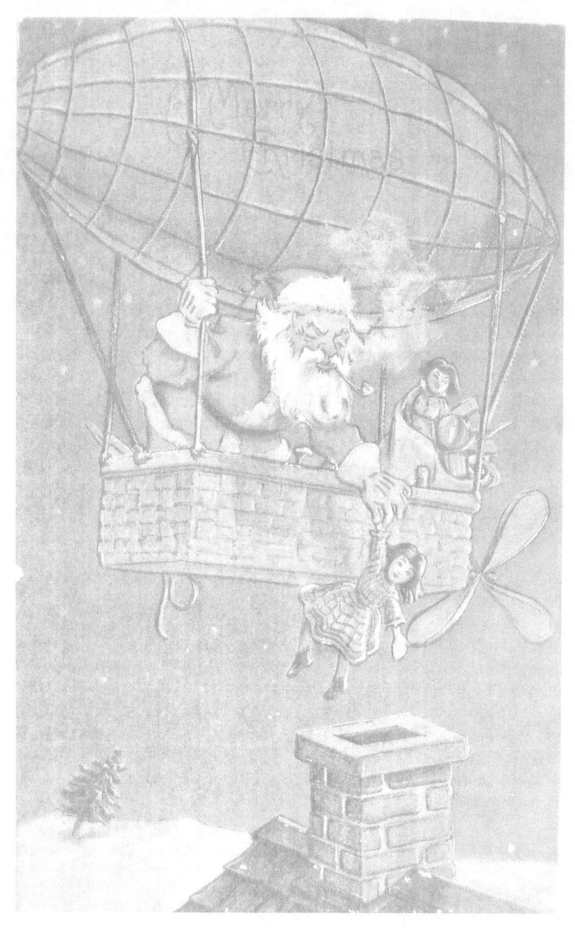

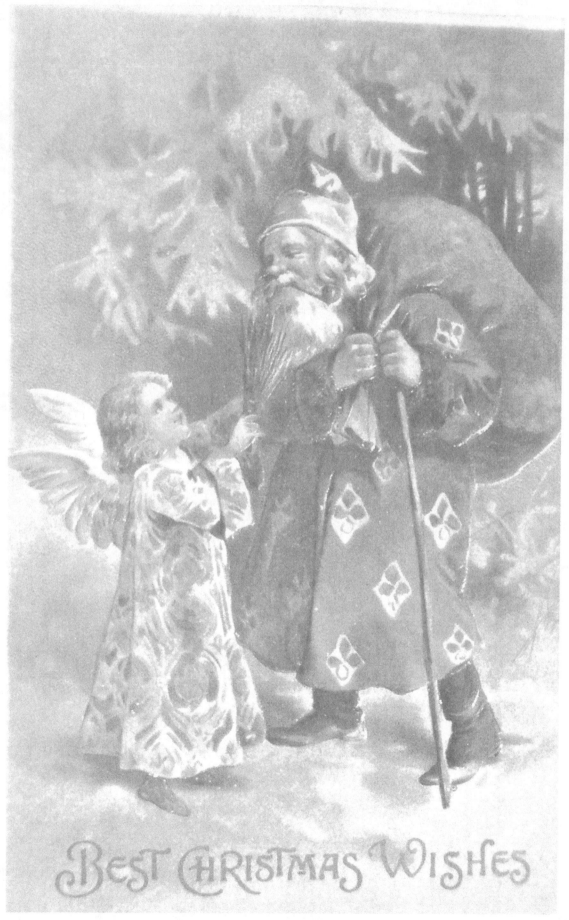

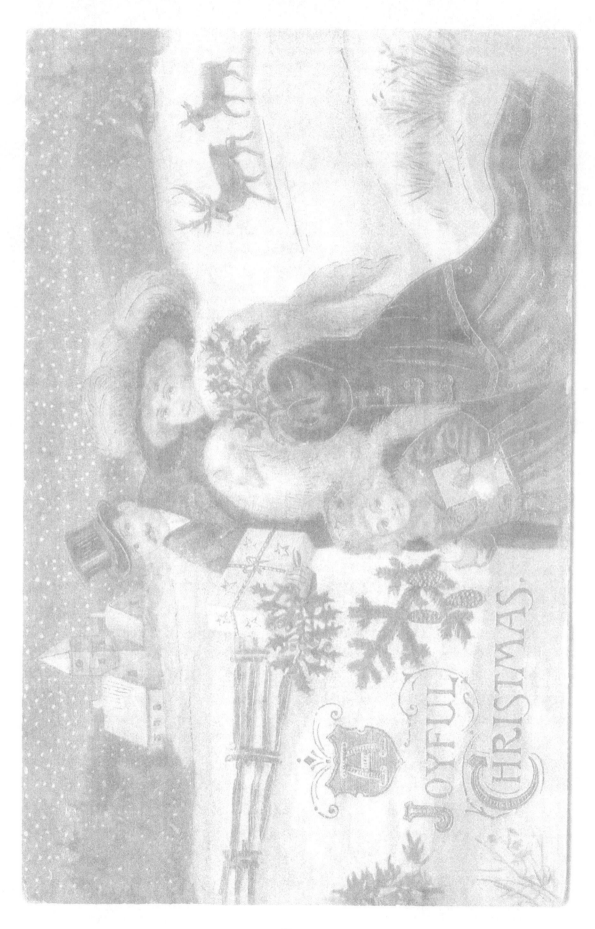

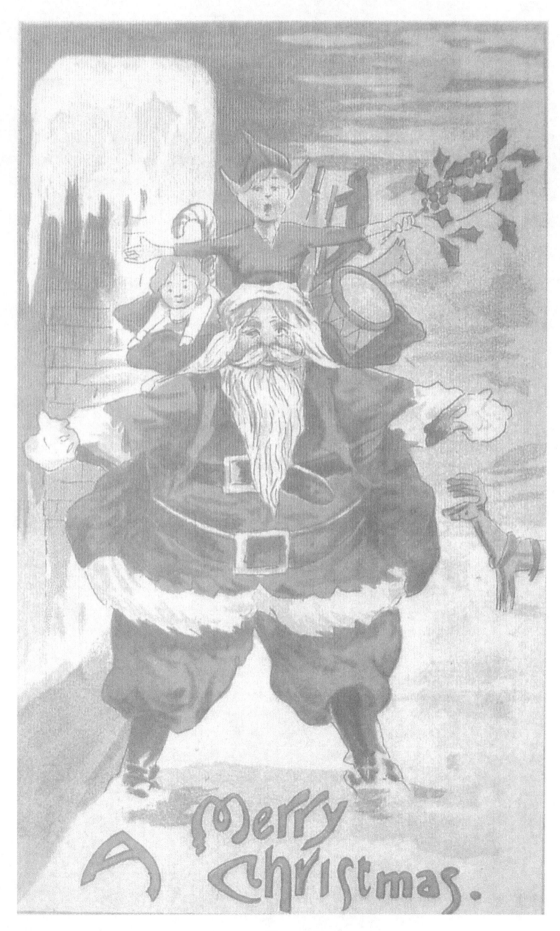

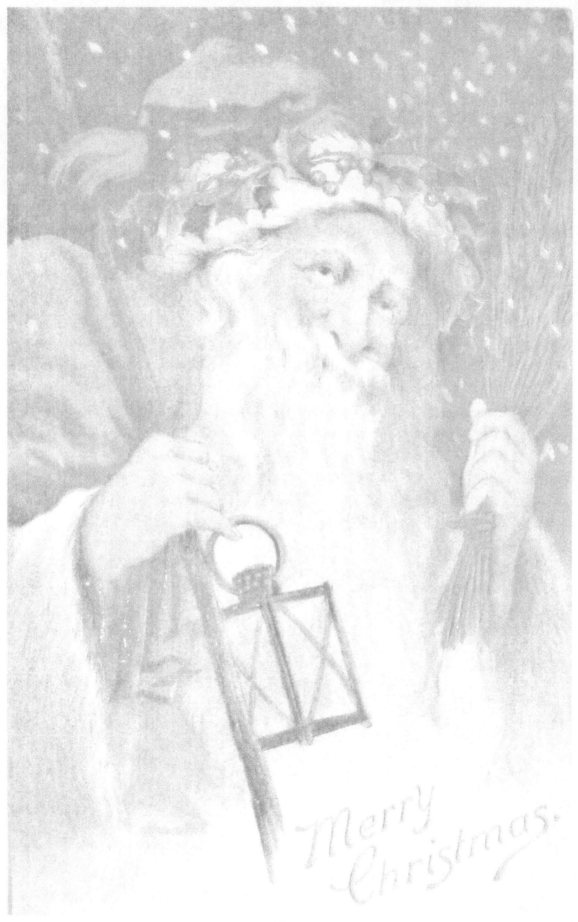

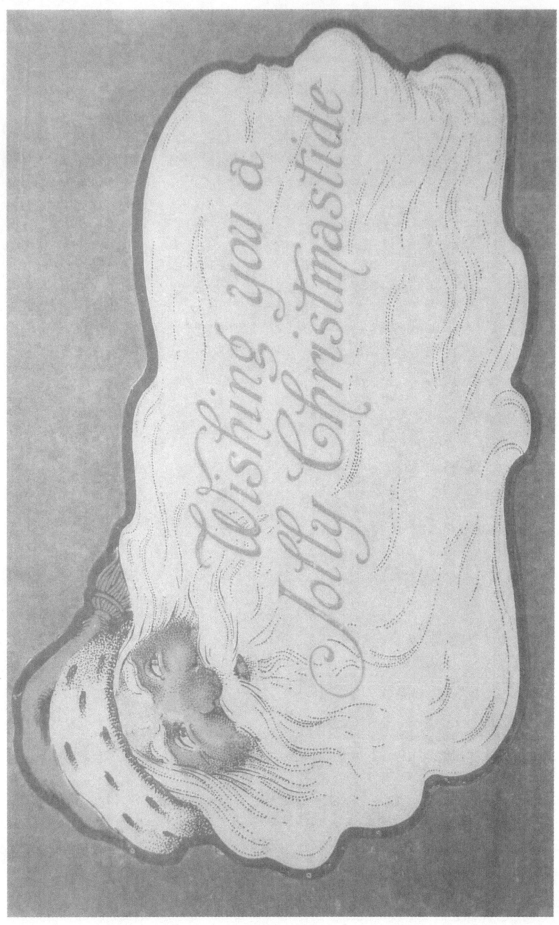

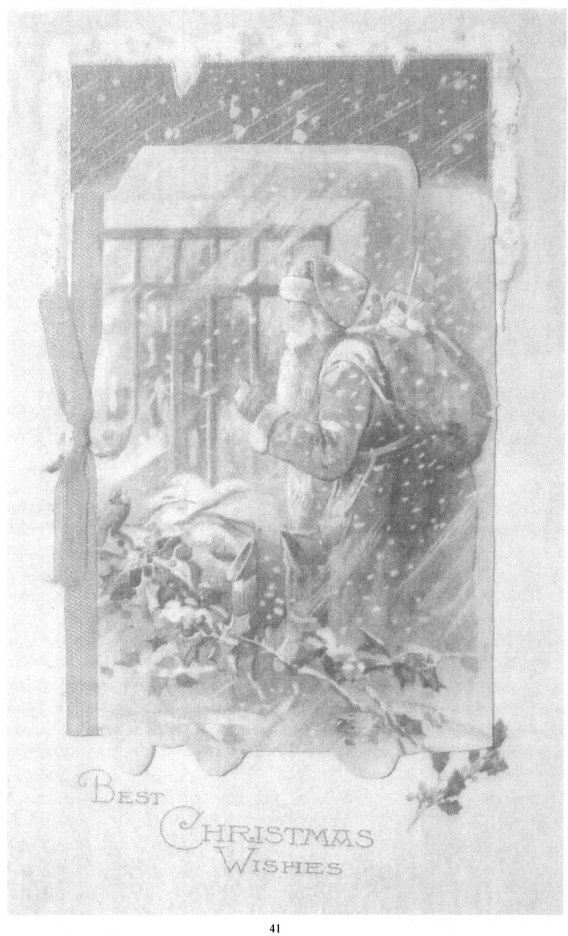

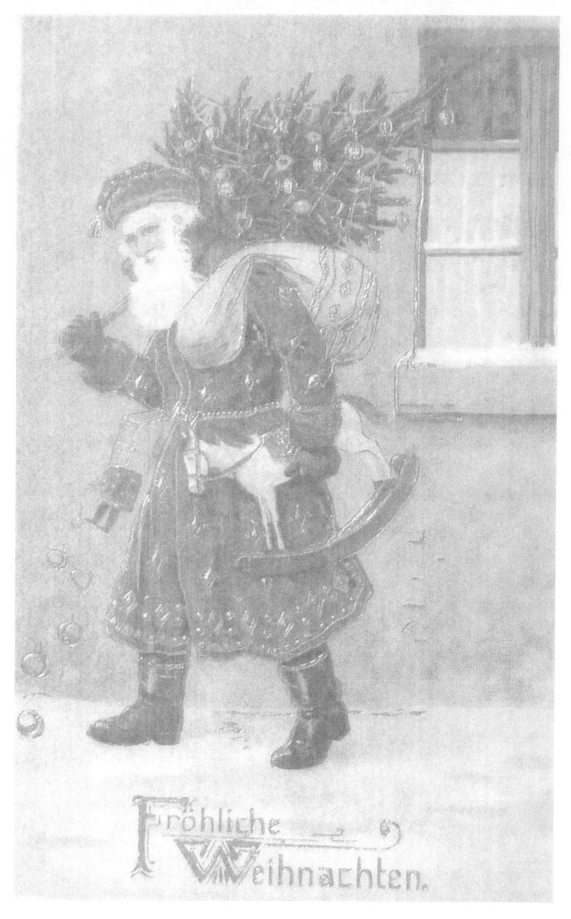

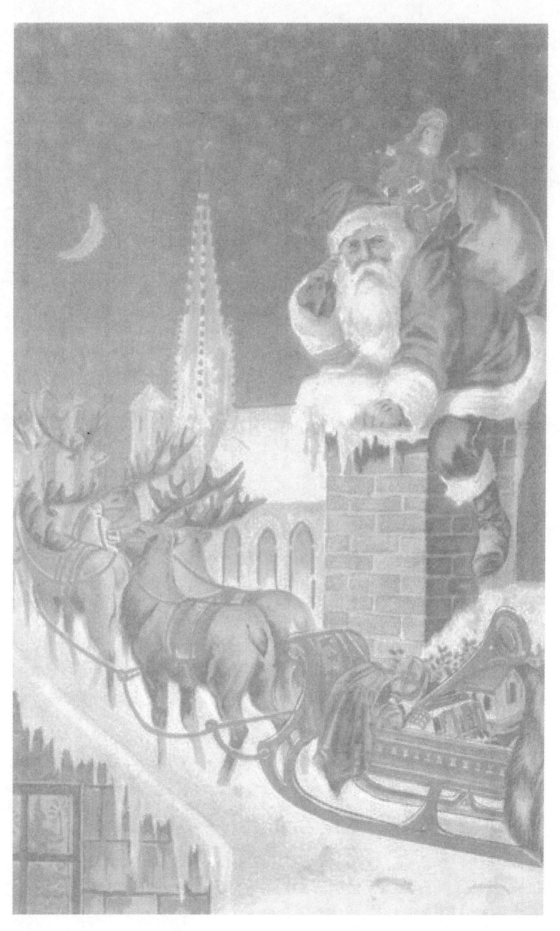

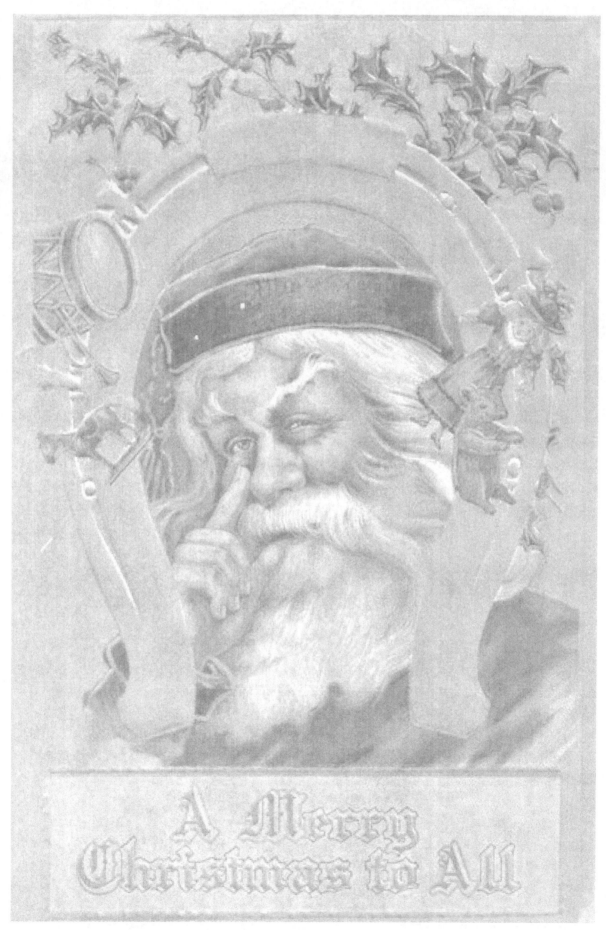

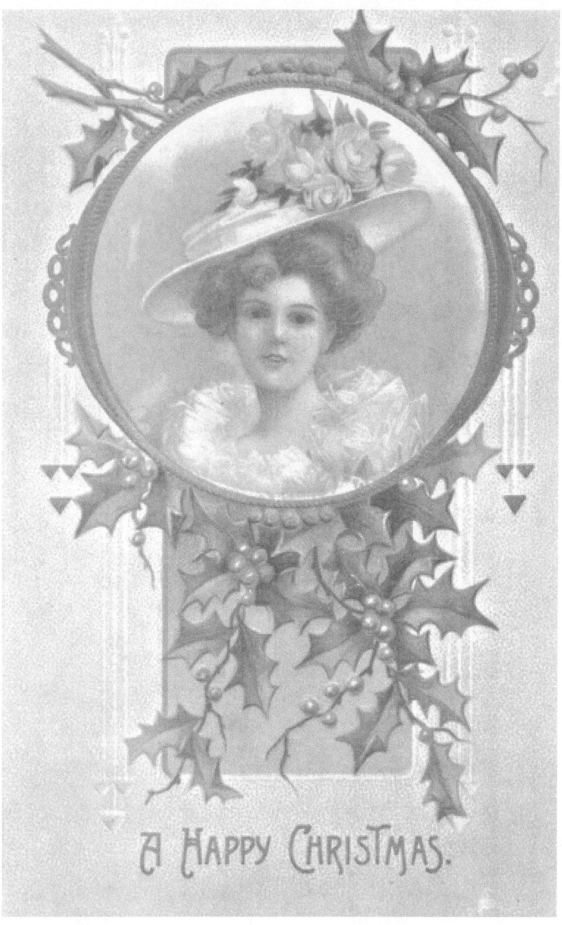

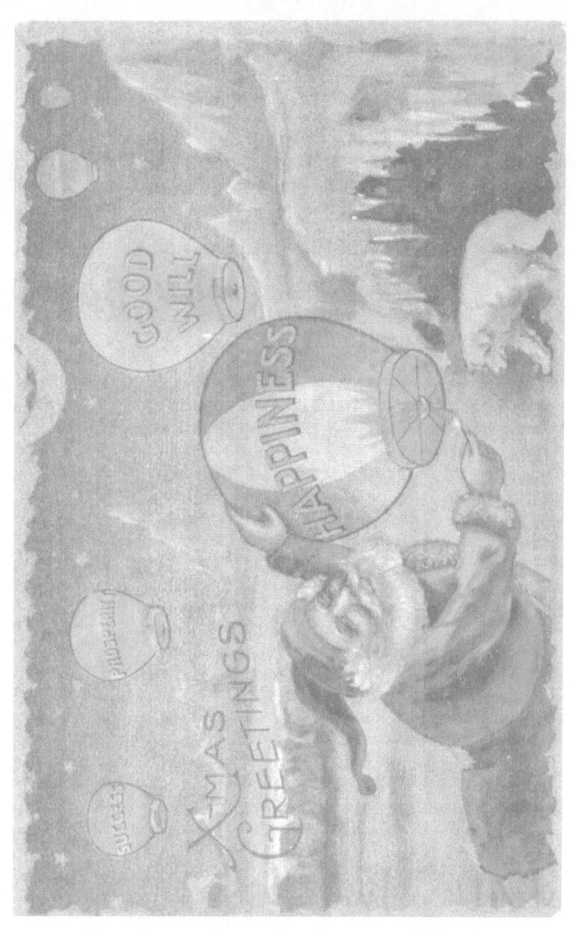

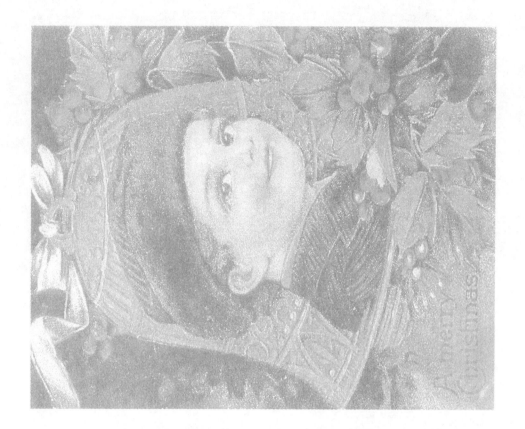

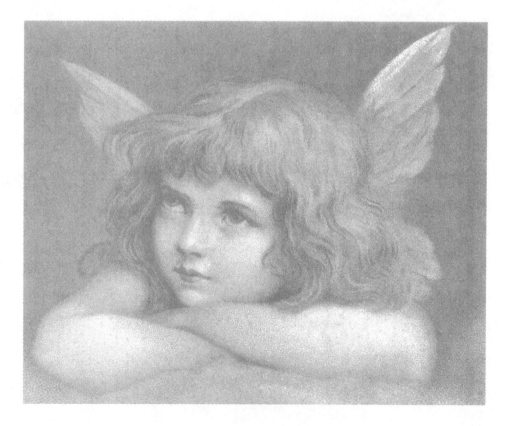

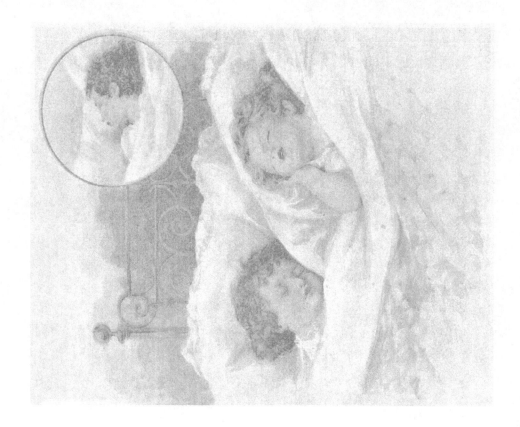

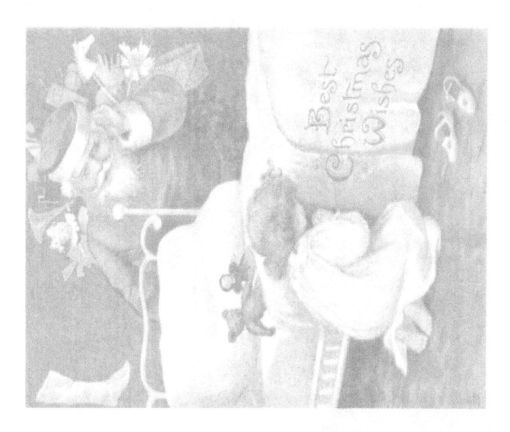

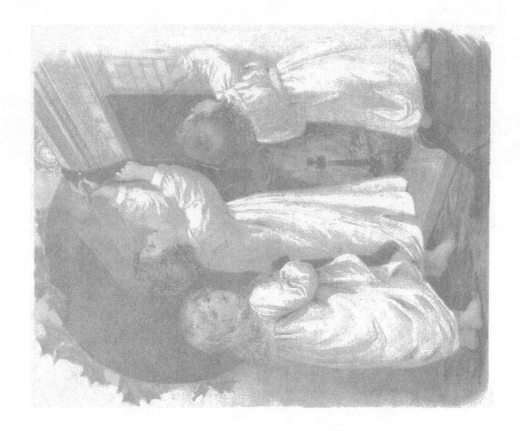

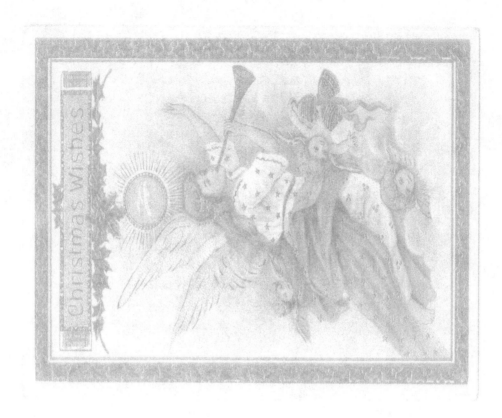

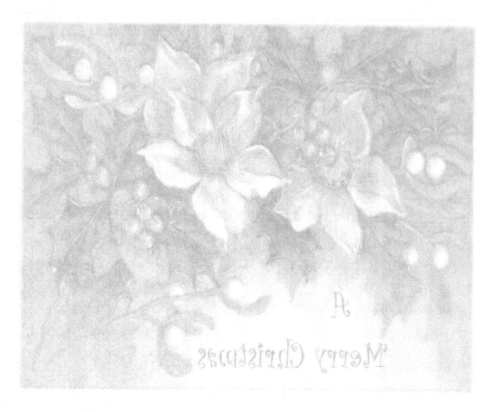

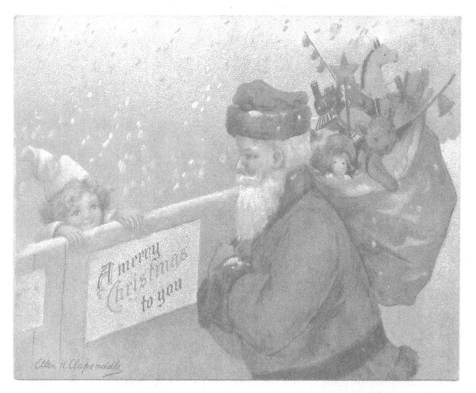

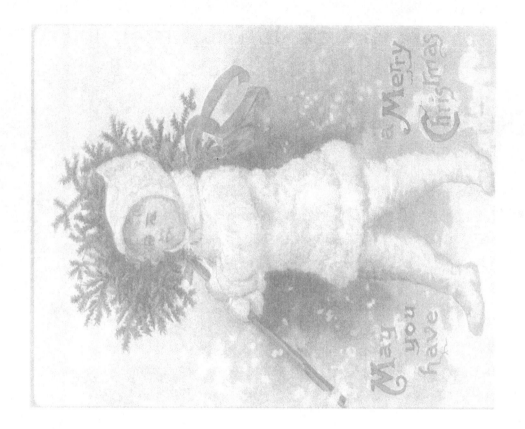

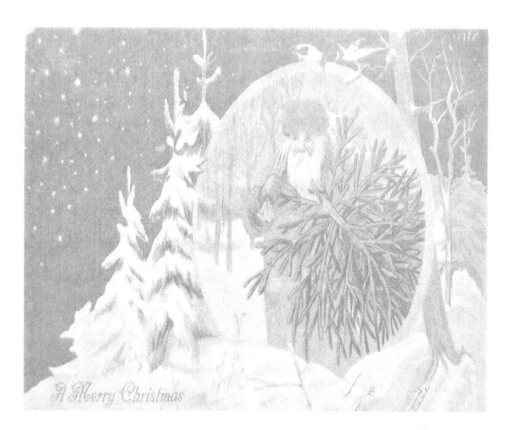

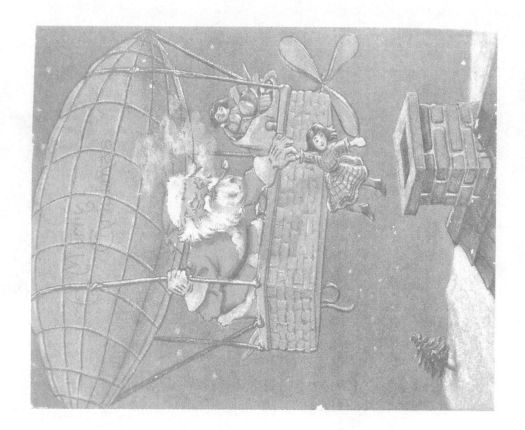

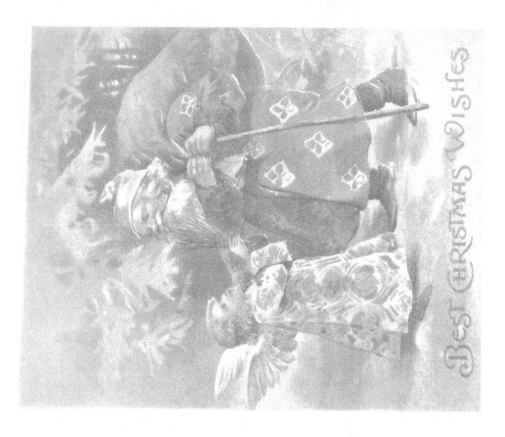

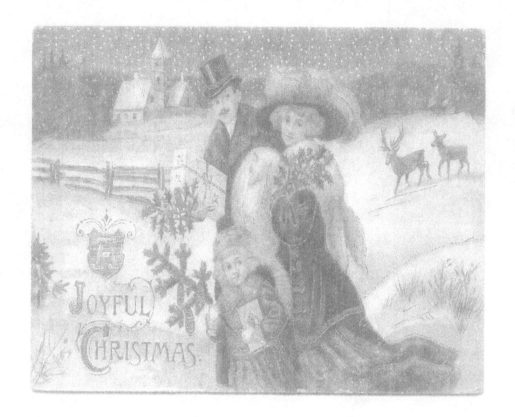

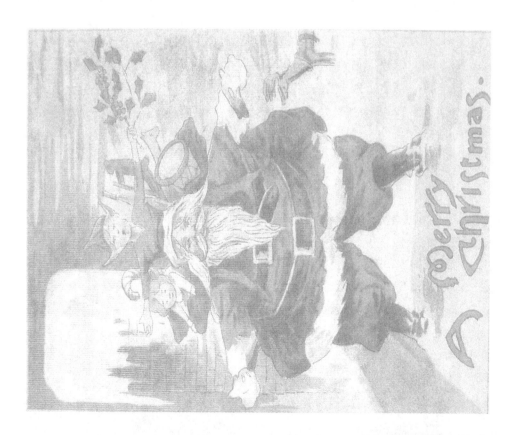

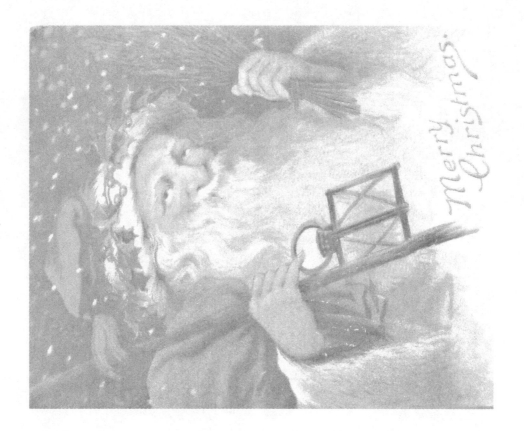

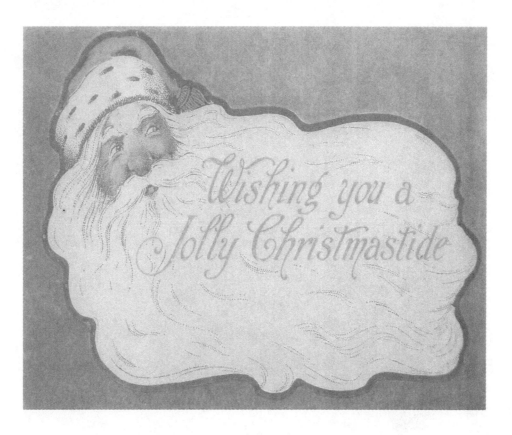

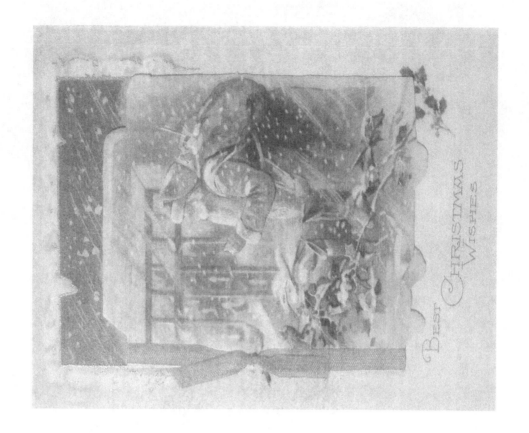

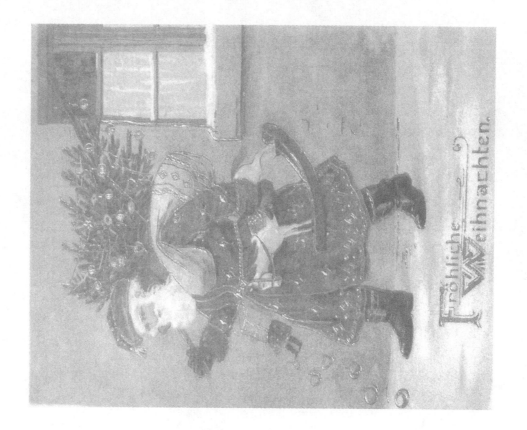

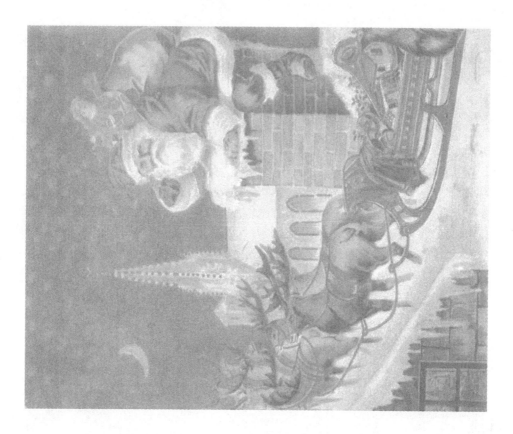

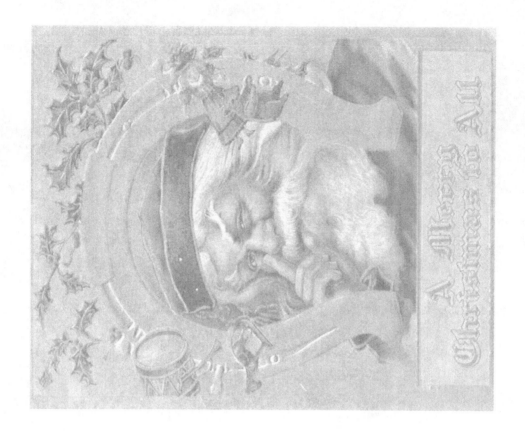

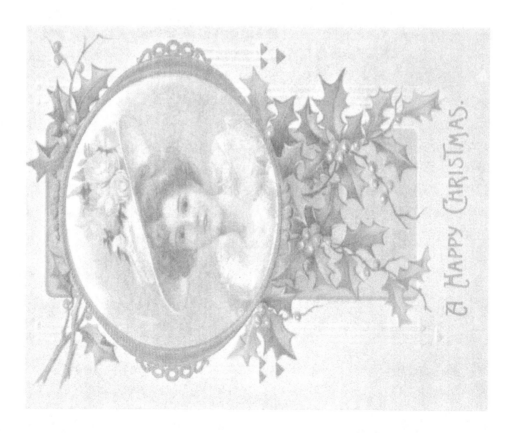

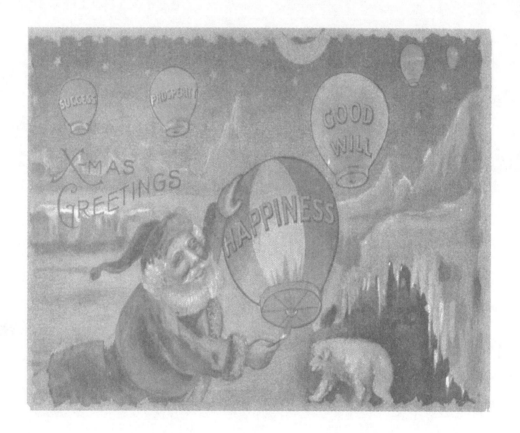

I hope you enjoyed these lovely grayscale Vintage post cards to color. Thank you for purchasing. Please go back to where you bought this book and leave feedback. It really helps the authors and potential buyers. Check out my website for other coloring books!

Facebook: Coloring Books For Adults Info

Website: http://www.ColoringBooksForAdults.info

Twitter: @ColoringAdults

CPSIA information can be obtained
at www.ICGtesting.com
Printed in the USA
LVOW09s2102121217
559534LV00008B/692/P